geomorphia

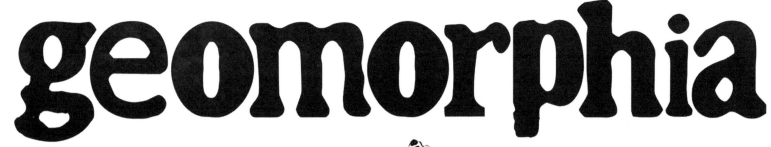

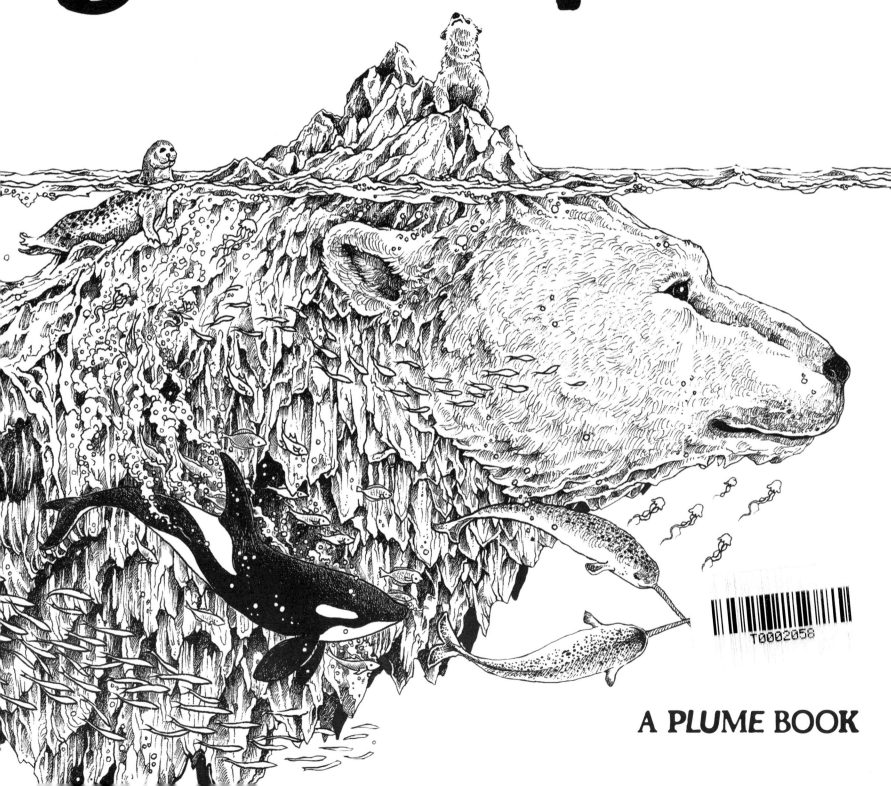

A **PLUME** BOOK

T0002058

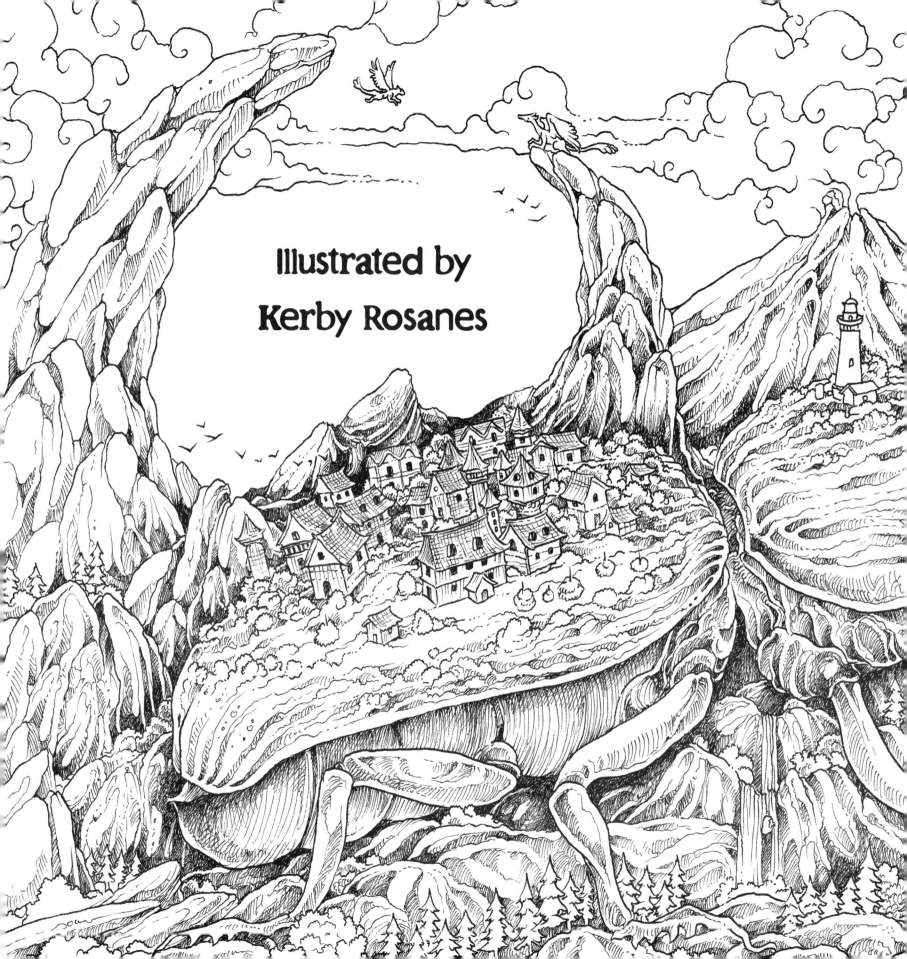

Illustrated by

Kerby Rosanes

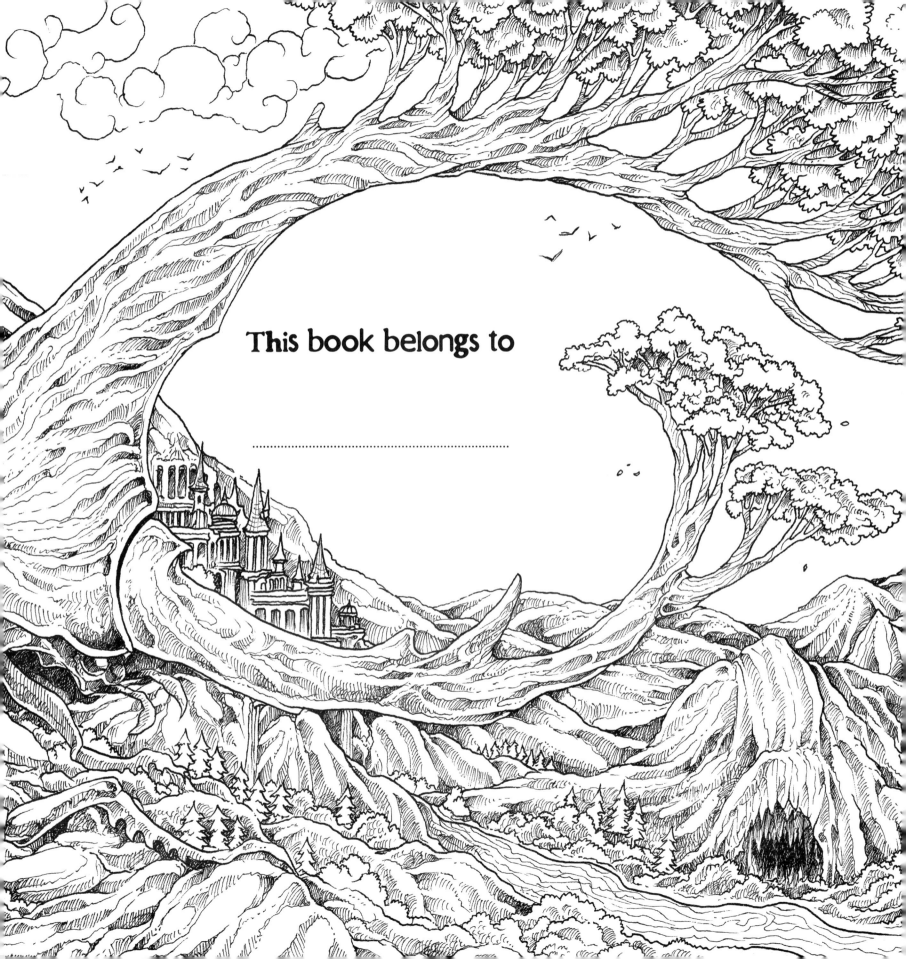

This book belongs to

..

Edited by Hannah Daffern
and Lauren Farnsworth
Designed by Derrian Bradder
Cover Design by Angie Allison
and Derrian Bradder

With thanks to Harry Thornton
for being a great talent scout

PLUME
An imprint of Penguin Random House LLC
375 Hudson Street
New York, New York 10014

First published in Great Britain in 2018 by
LOM ART, an imprint of Michael O'Mara Books Limited,
9 Lion Yard, Tremadoc Road, London SW4 7NQ

W www.mombooks.com/lom
f Michael O'Mara Books
@OMaraBooks

ISBN: 9780525536734

Printed in the United States of America
3rd Printing

Explore this geo-tastic coloring adventure!

Dive into my high-definition, super-detailed doodle realm where animals and scenes from nature morph into majestic geographic detail.

Each detailed drawing has been crafted with fineliner pens and can be colored in any way you like.

Keep your wits about you to find search objects scattered throughout the pages. You'll find a list of these hidden gems at the back of the book, so you know exactly what to look for, along with all the answers.

Kerby Rosanes

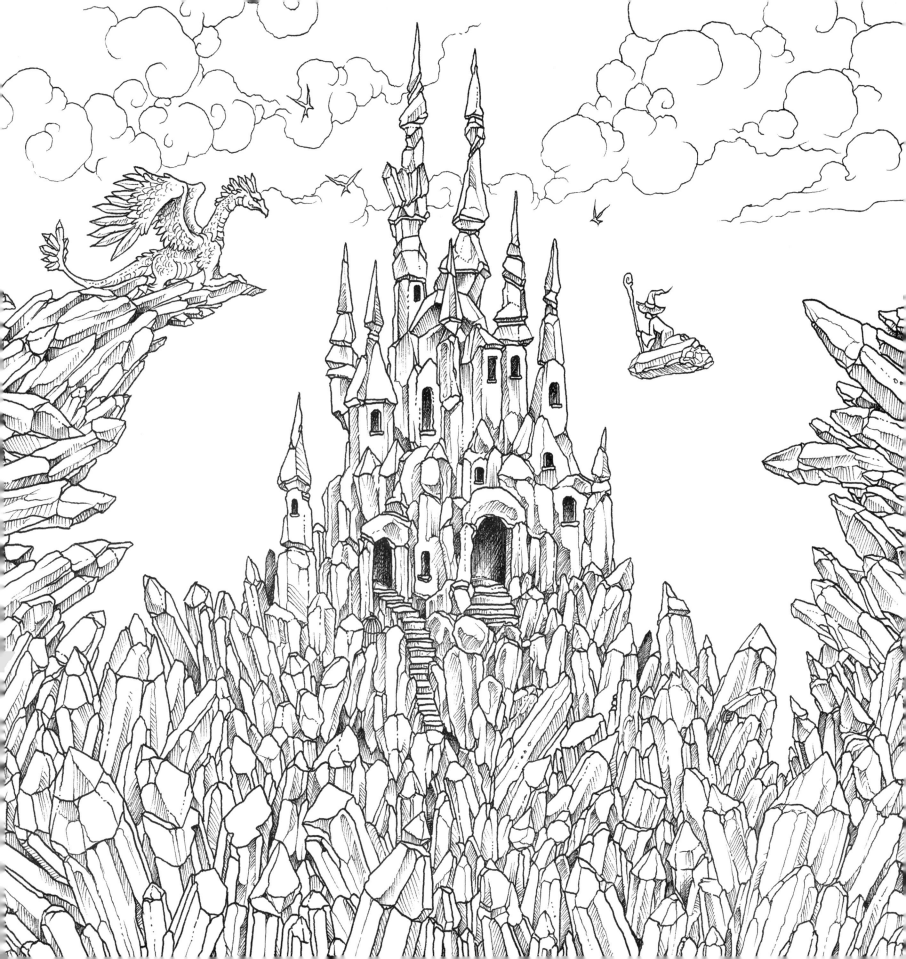

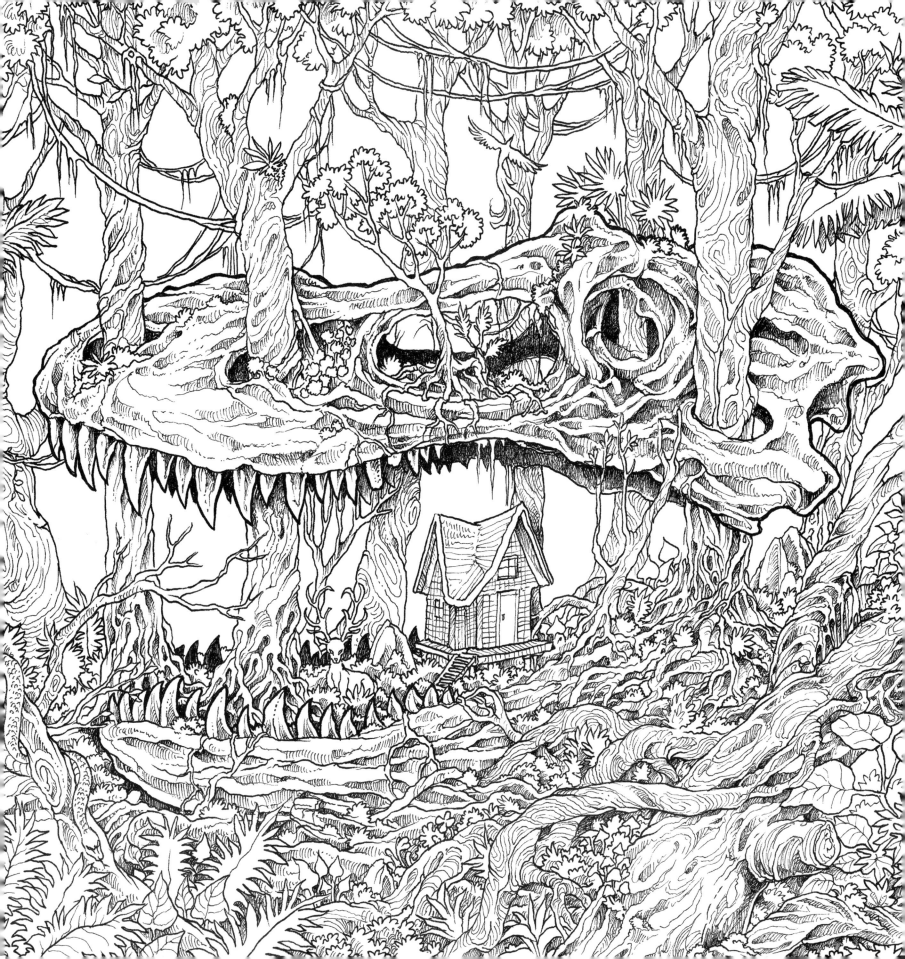

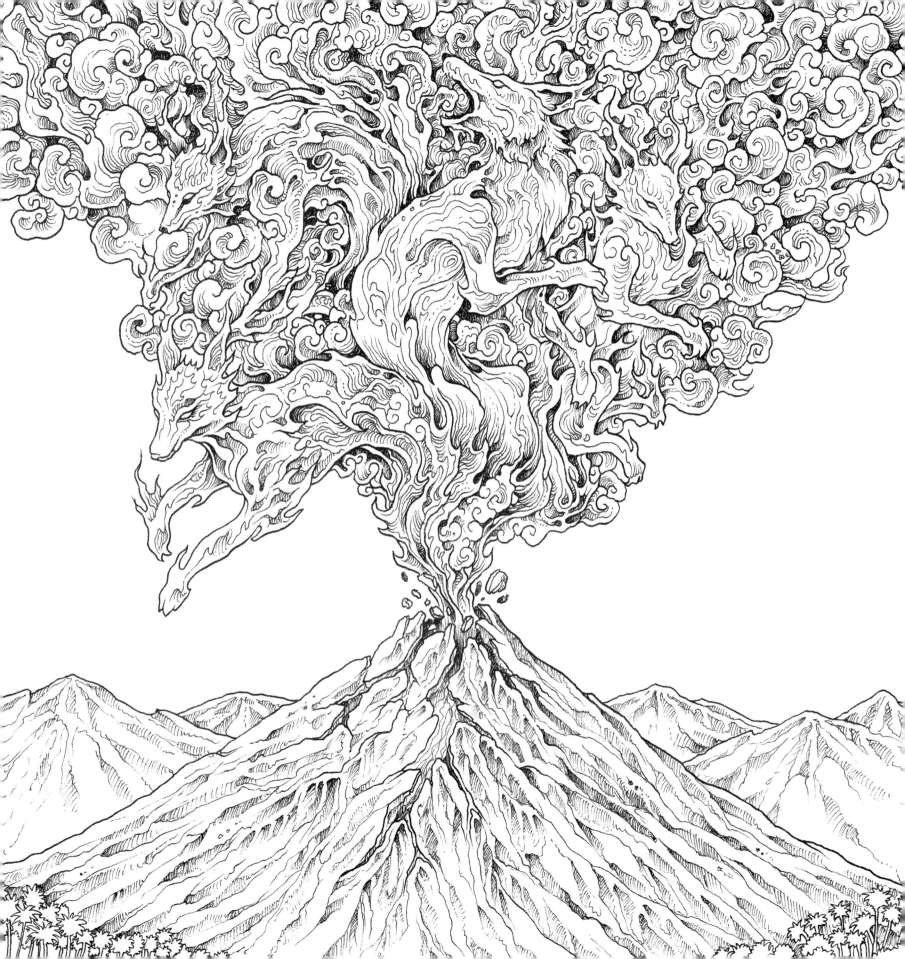

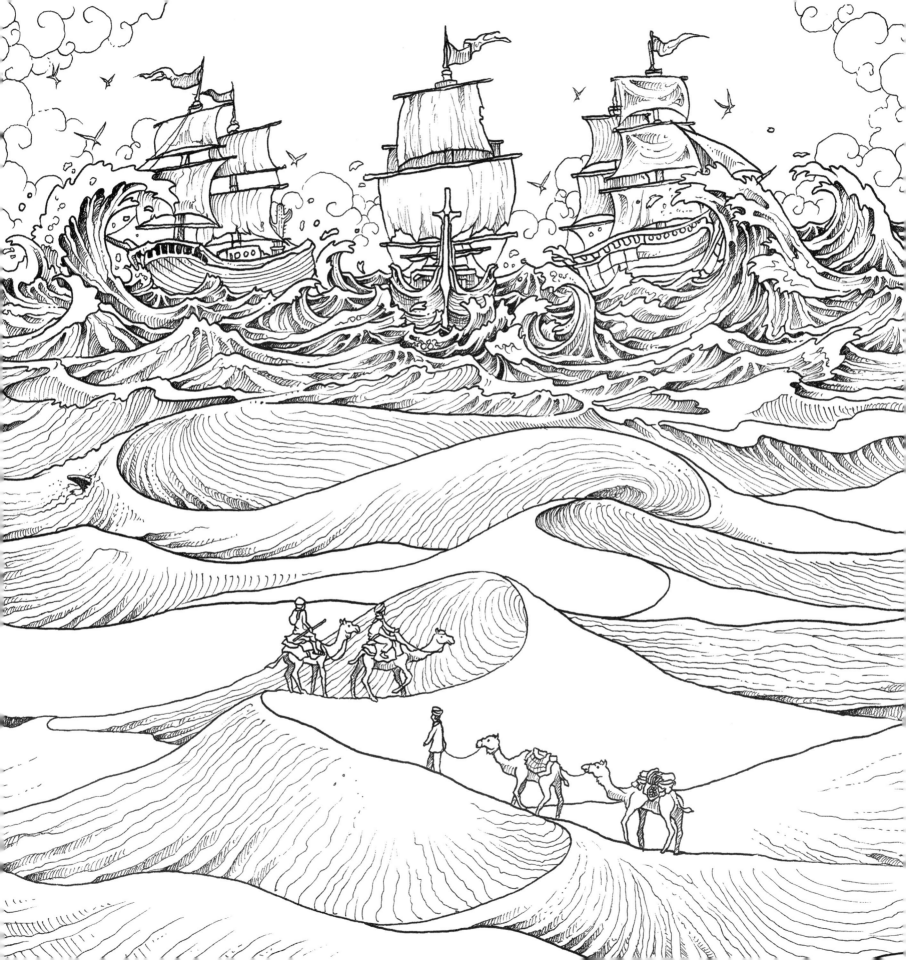

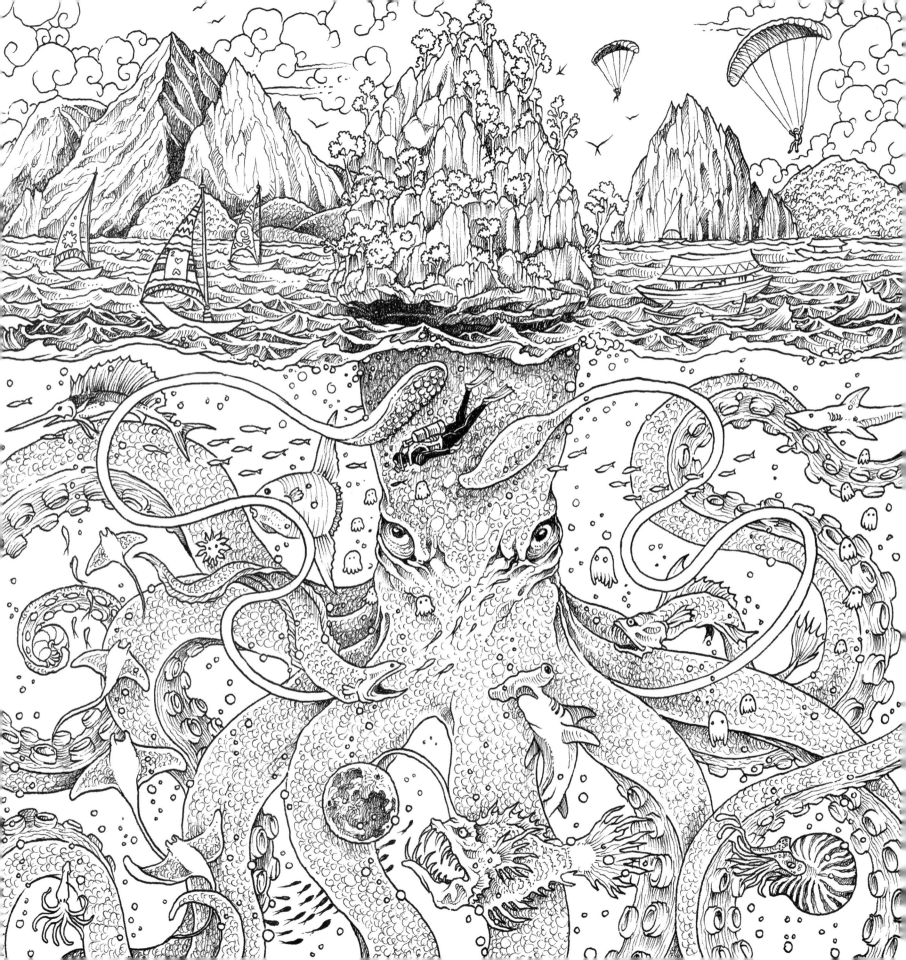

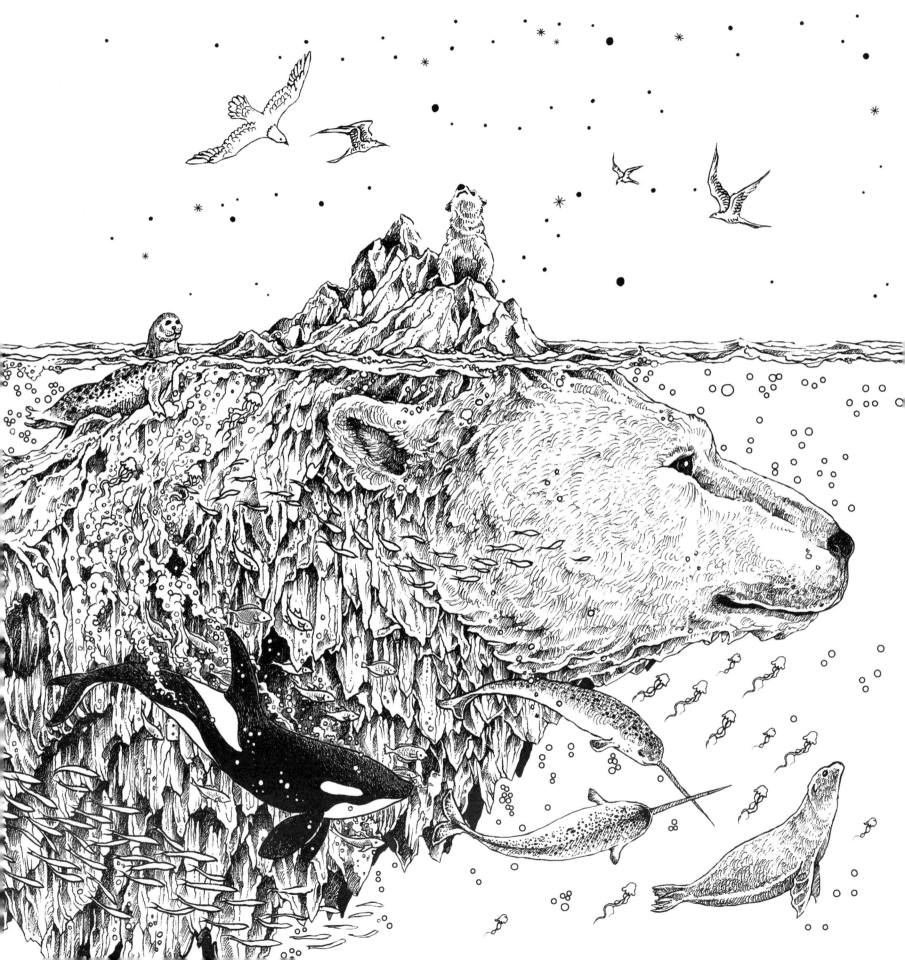

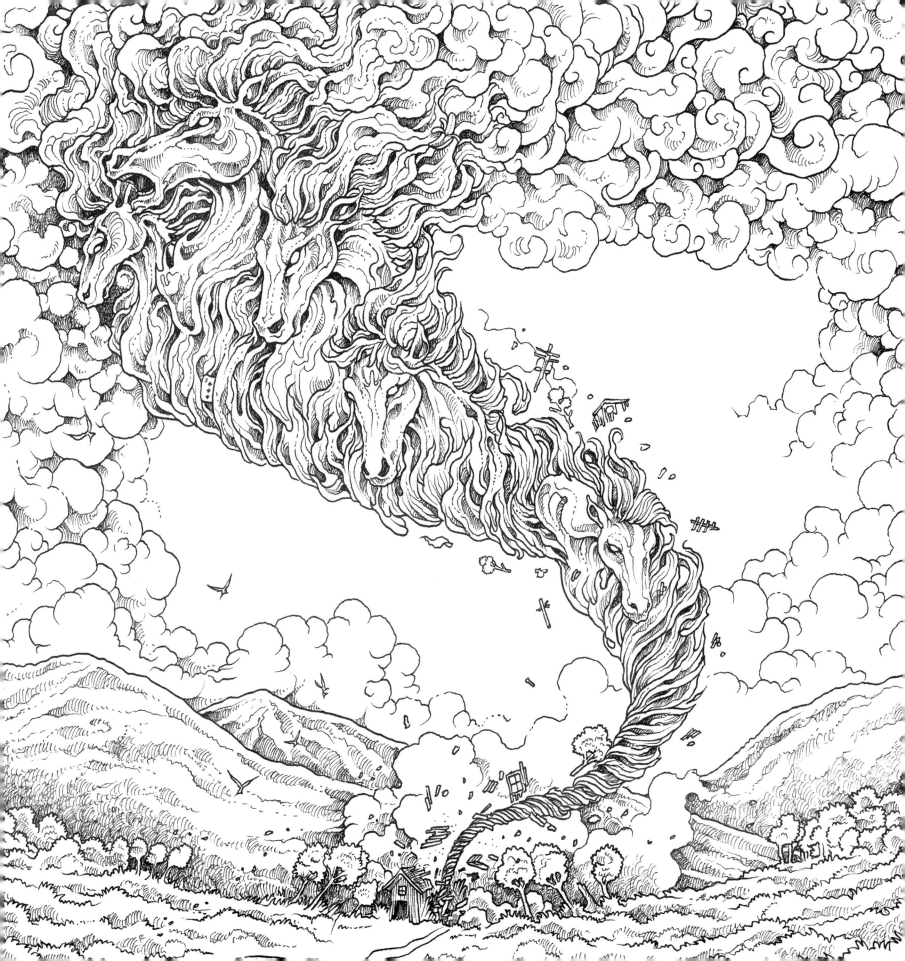

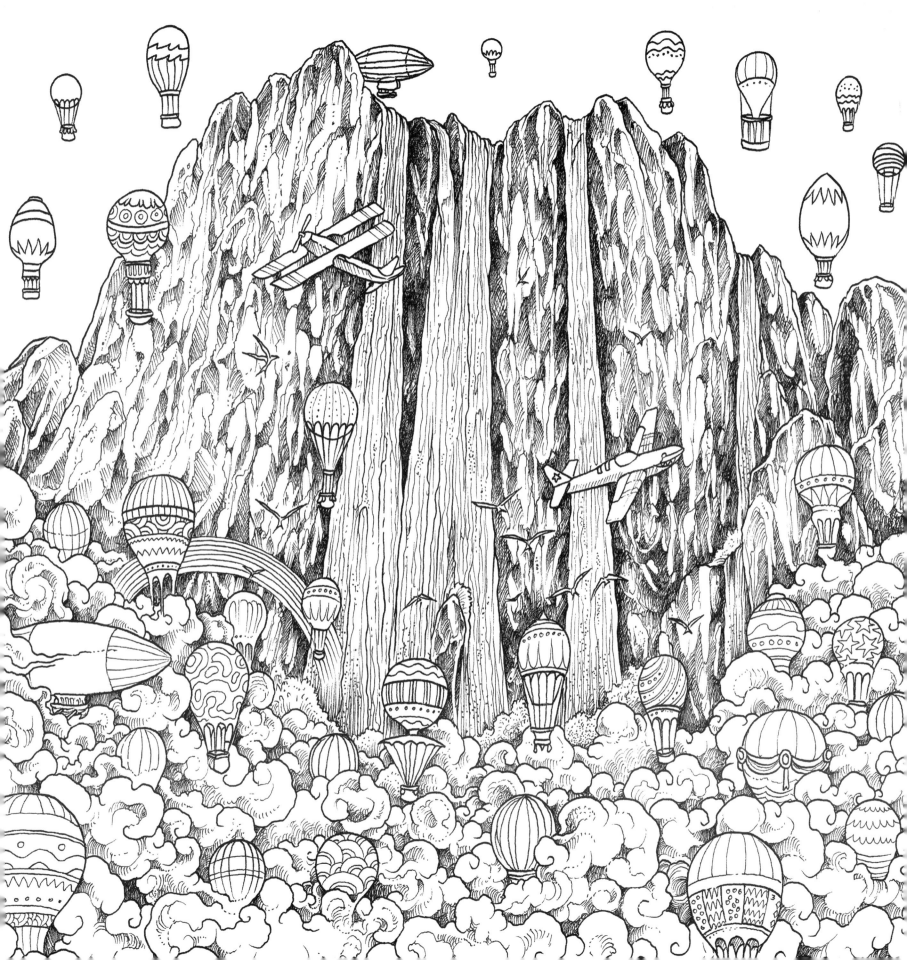

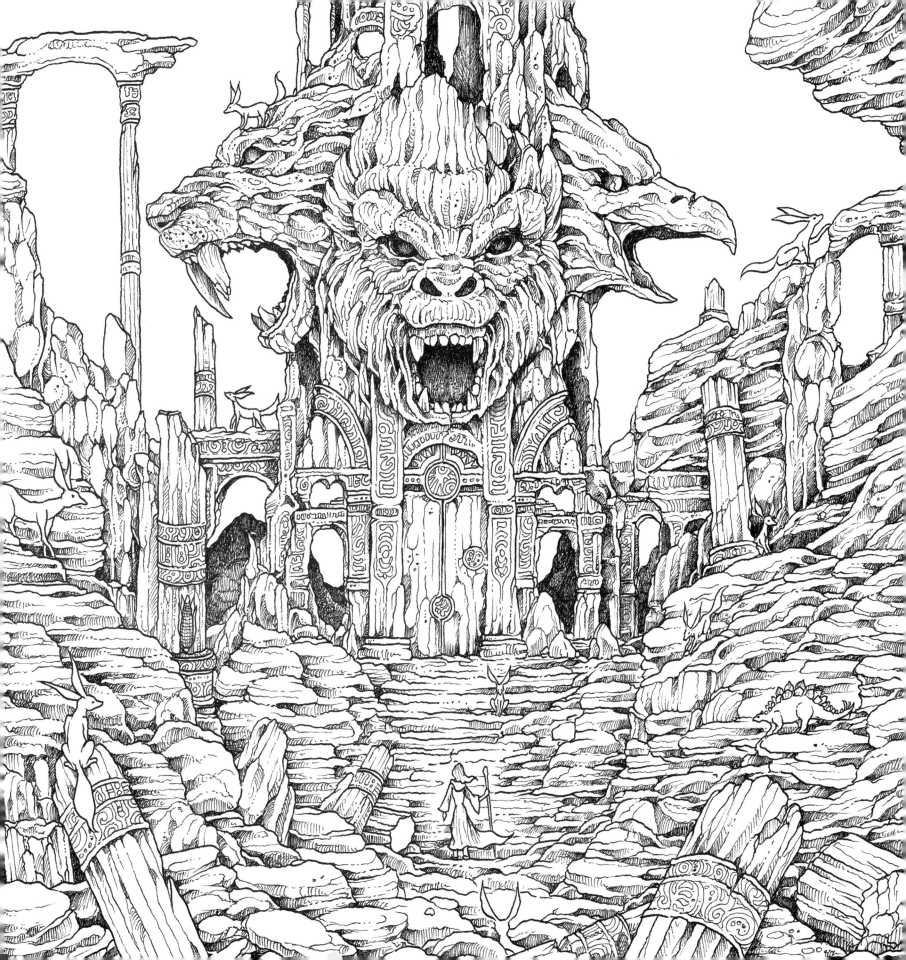

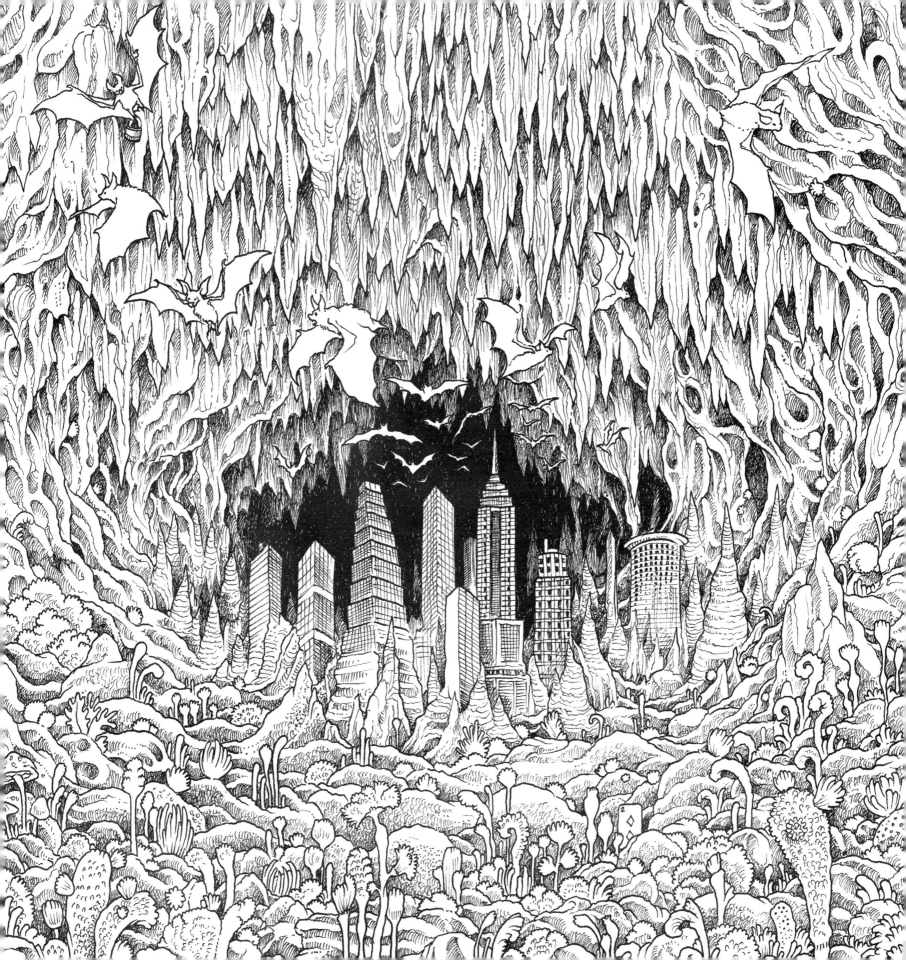

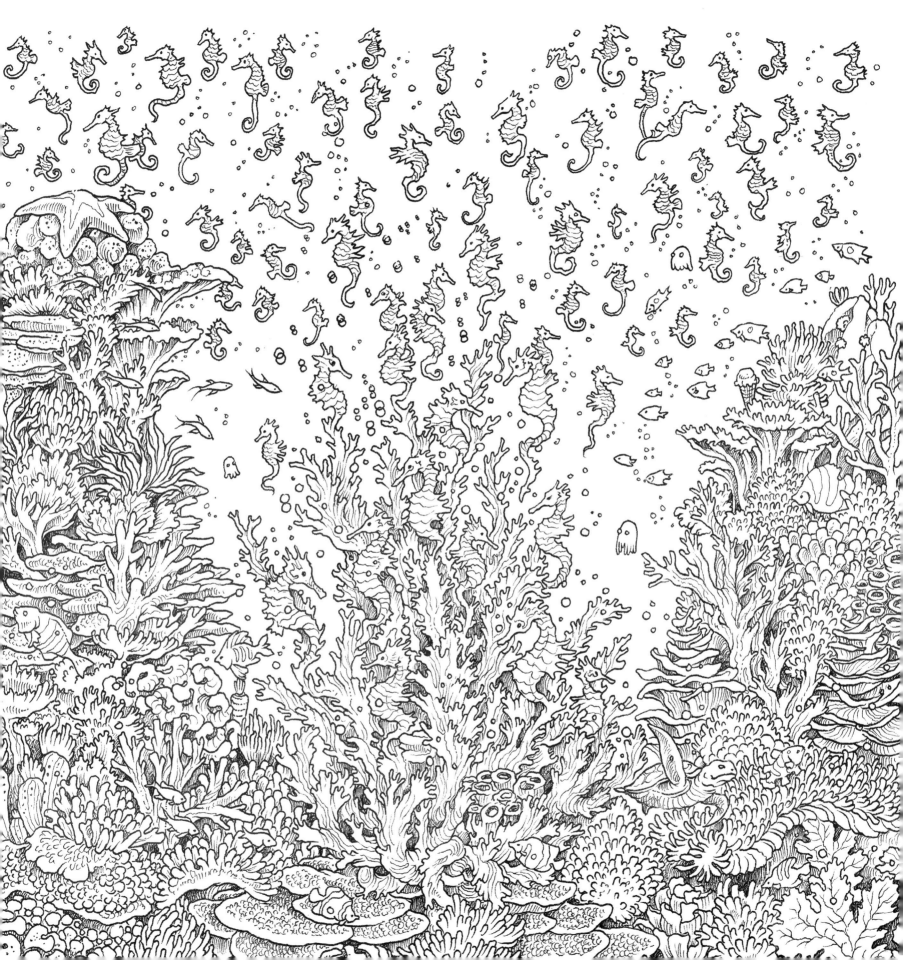

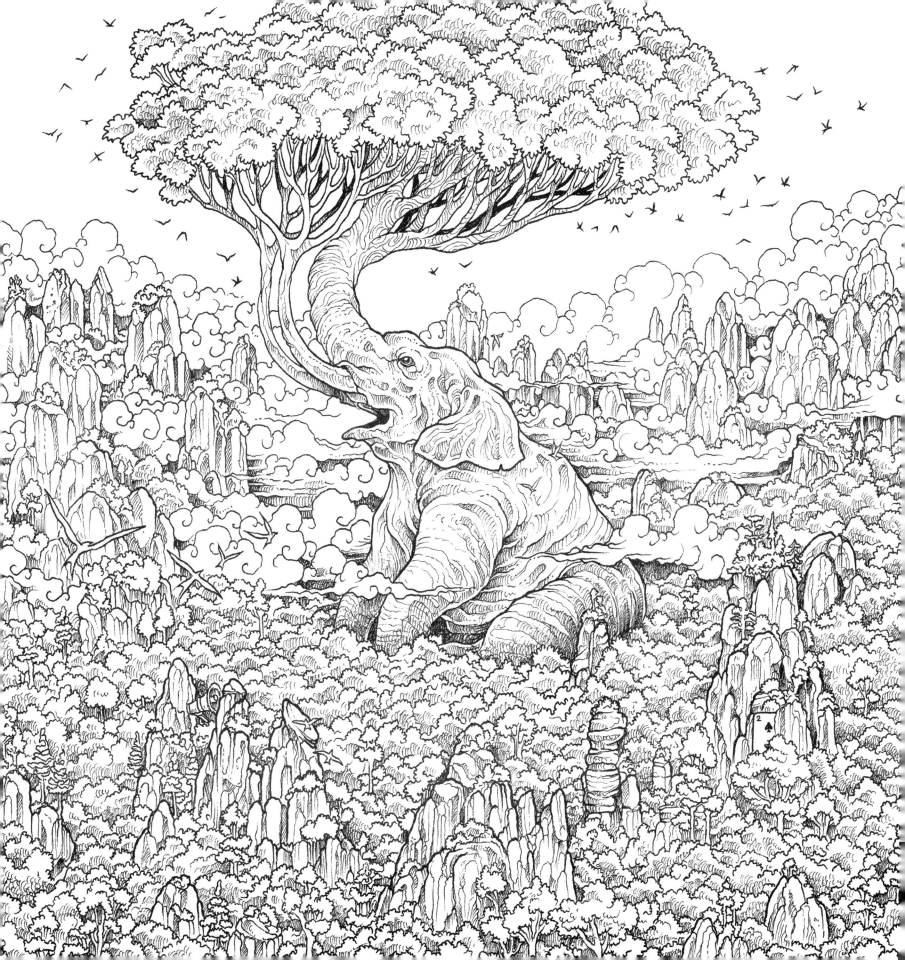

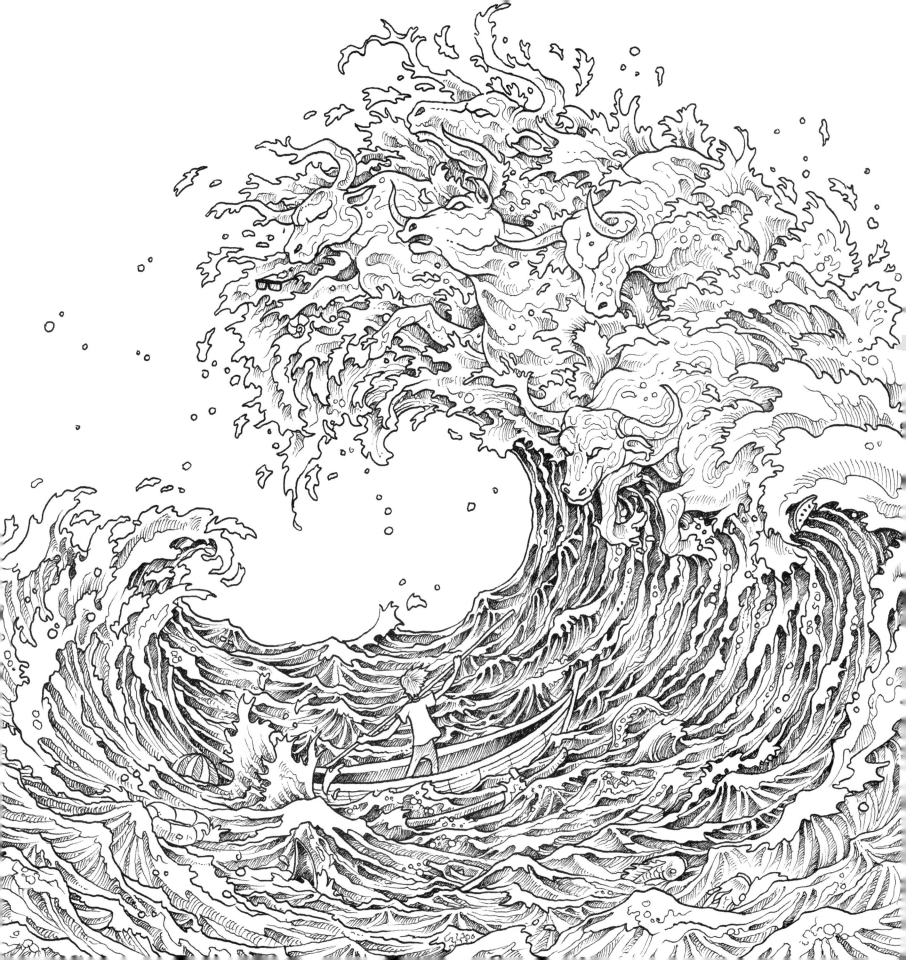

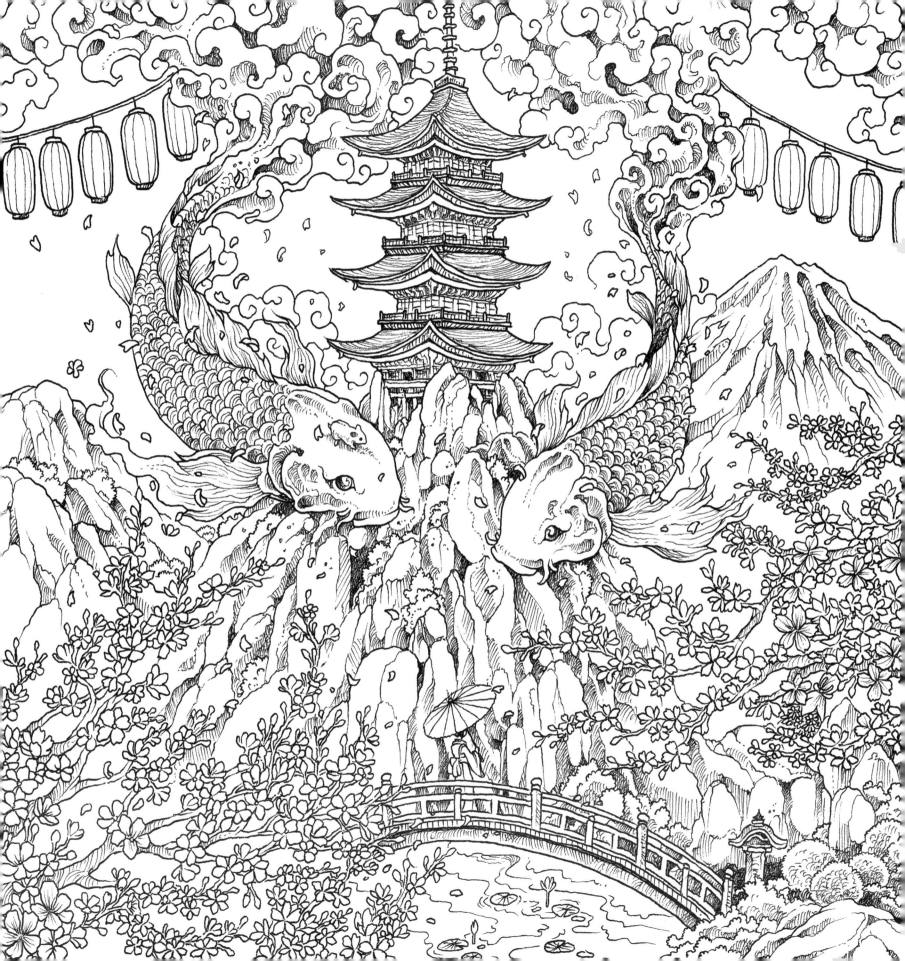

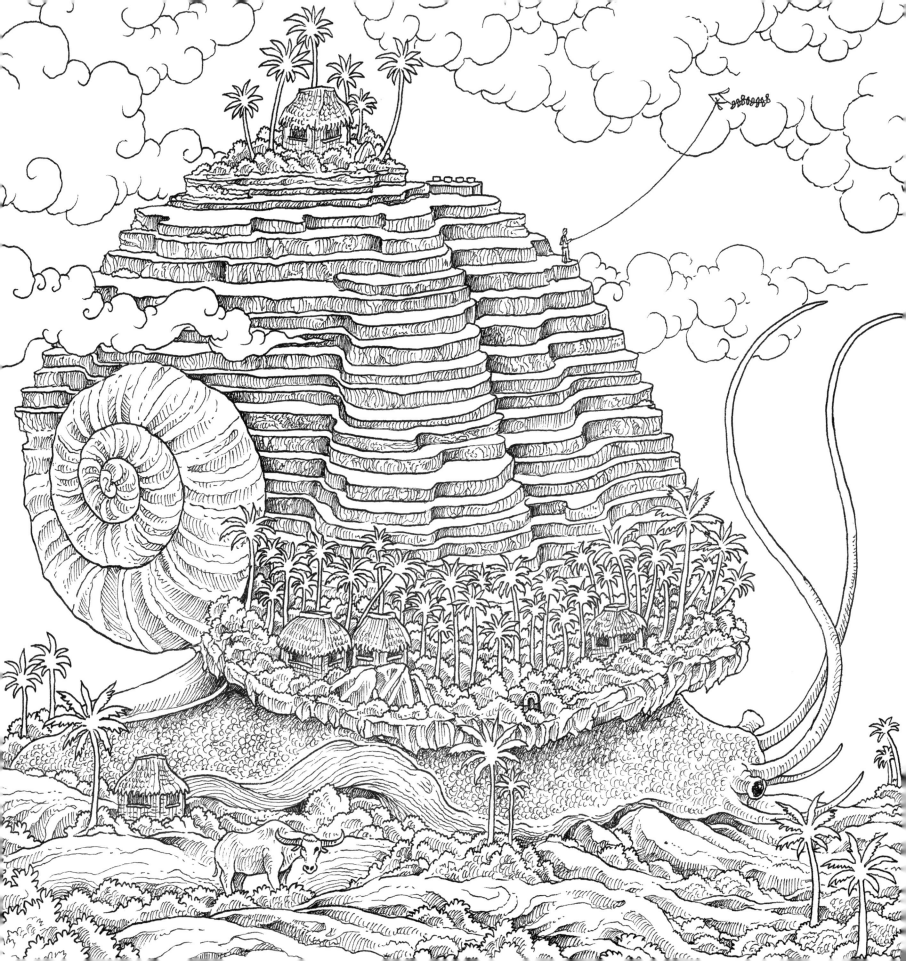

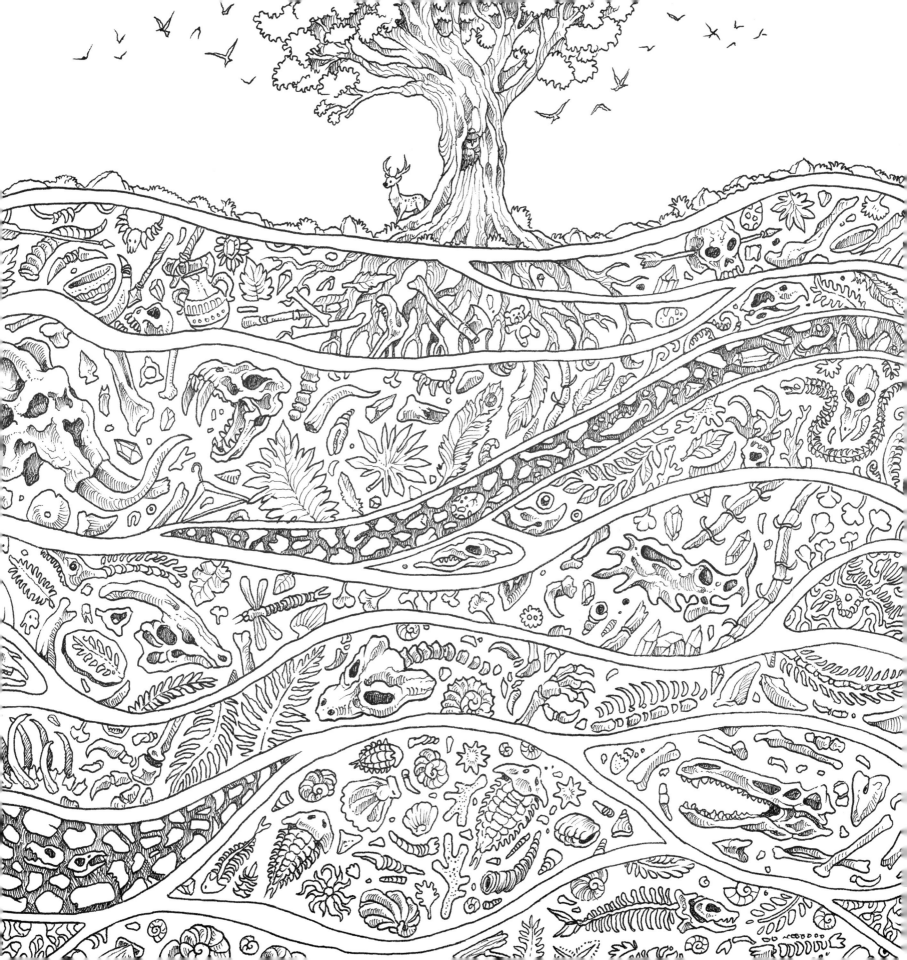

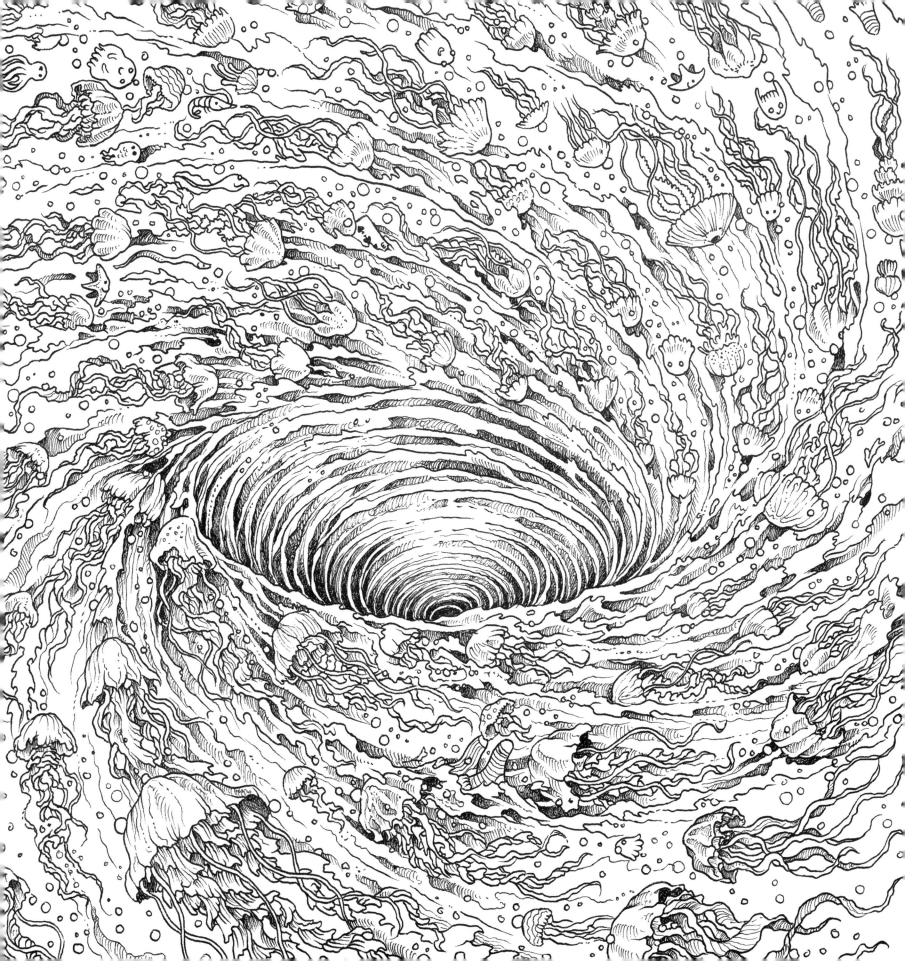

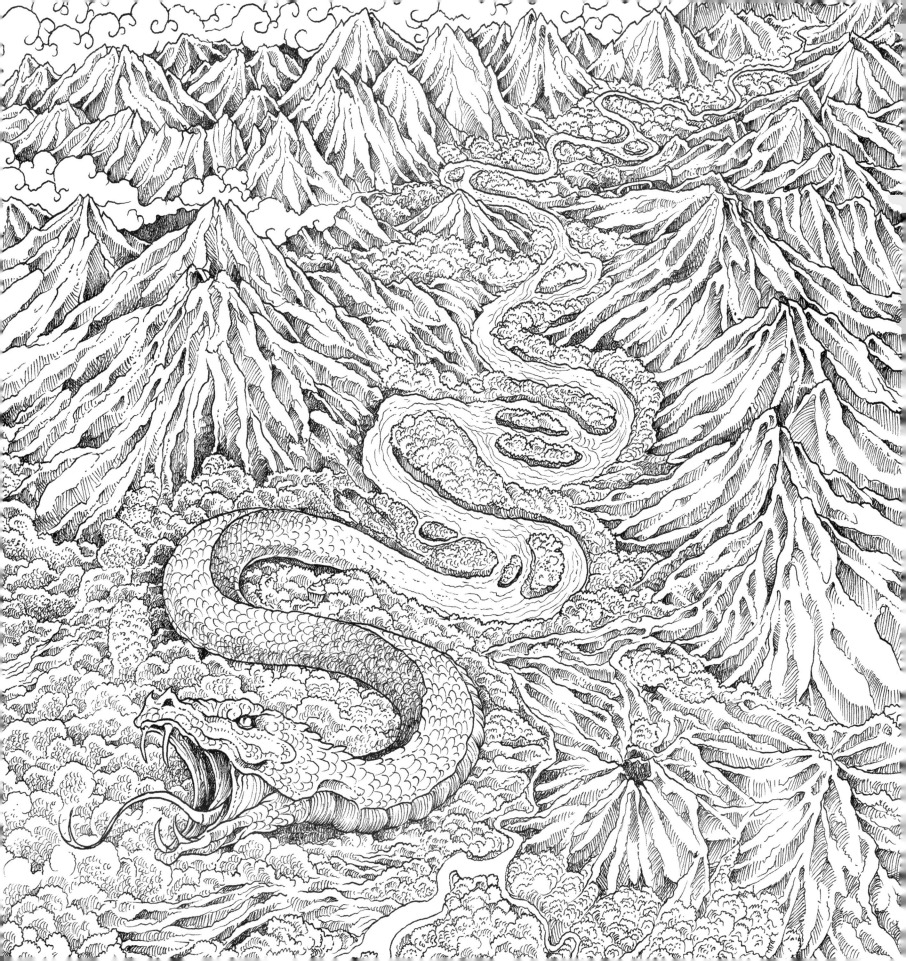

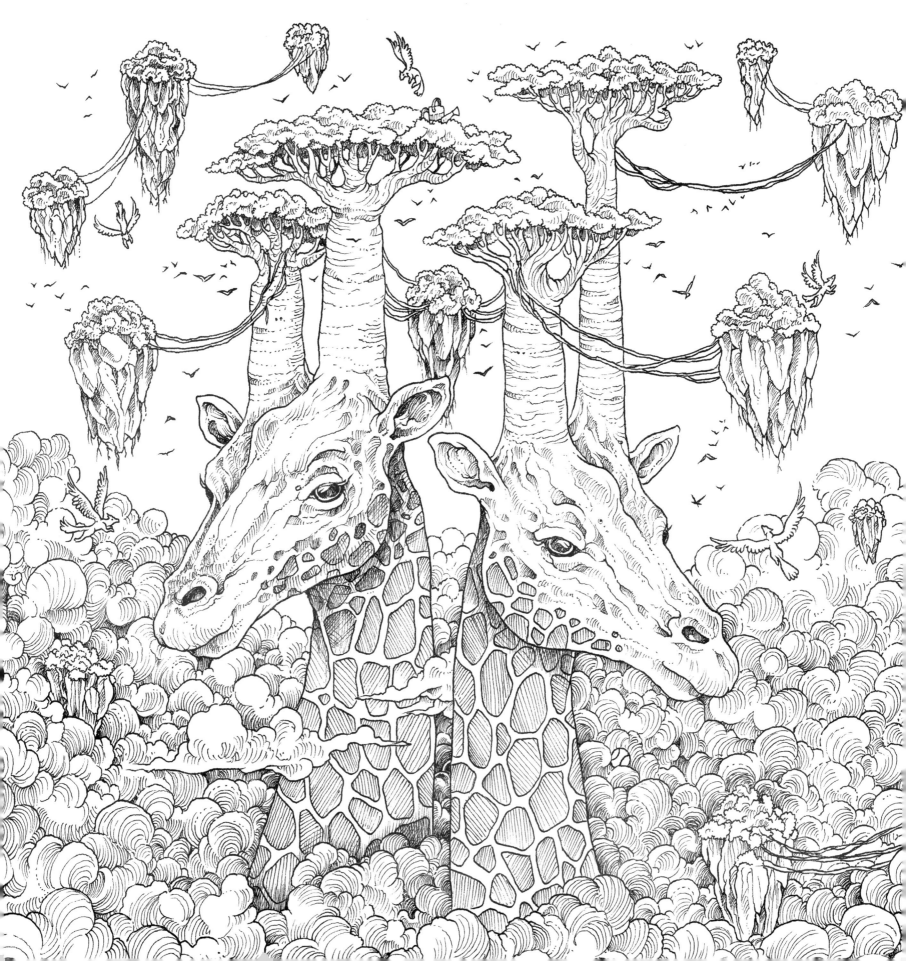

Can you find these items, artifacts, and creatures in the book?

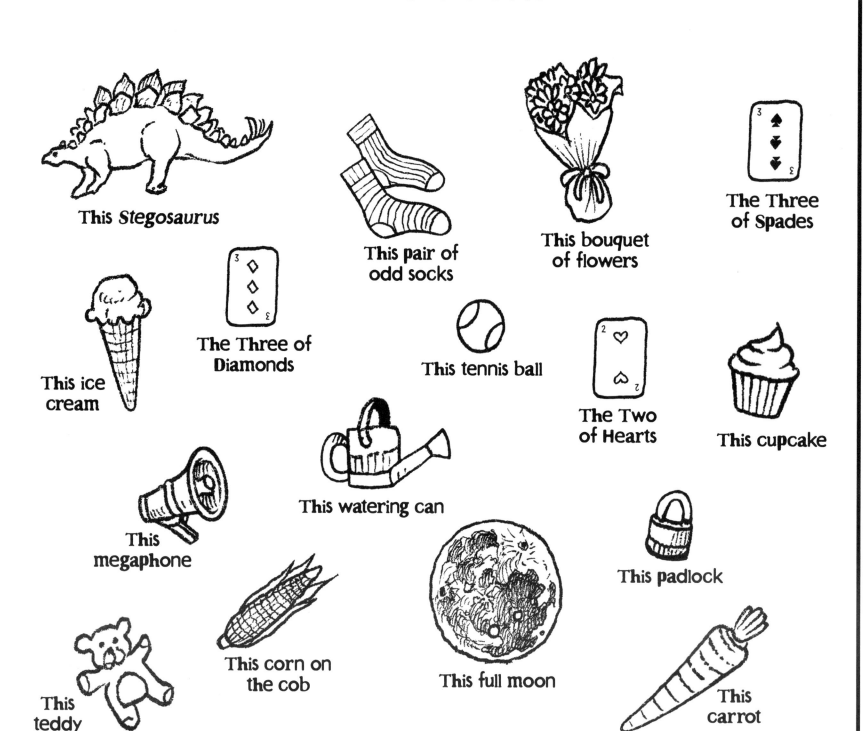

This *Stegosaurus*

This pair of odd socks

This bouquet of flowers

The Three of Spades

This ice cream

The Three of Diamonds

This tennis ball

The Two of Hearts

This cupcake

This megaphone

This watering can

This padlock

This teddy bear

This corn on the cob

This full moon

This carrot

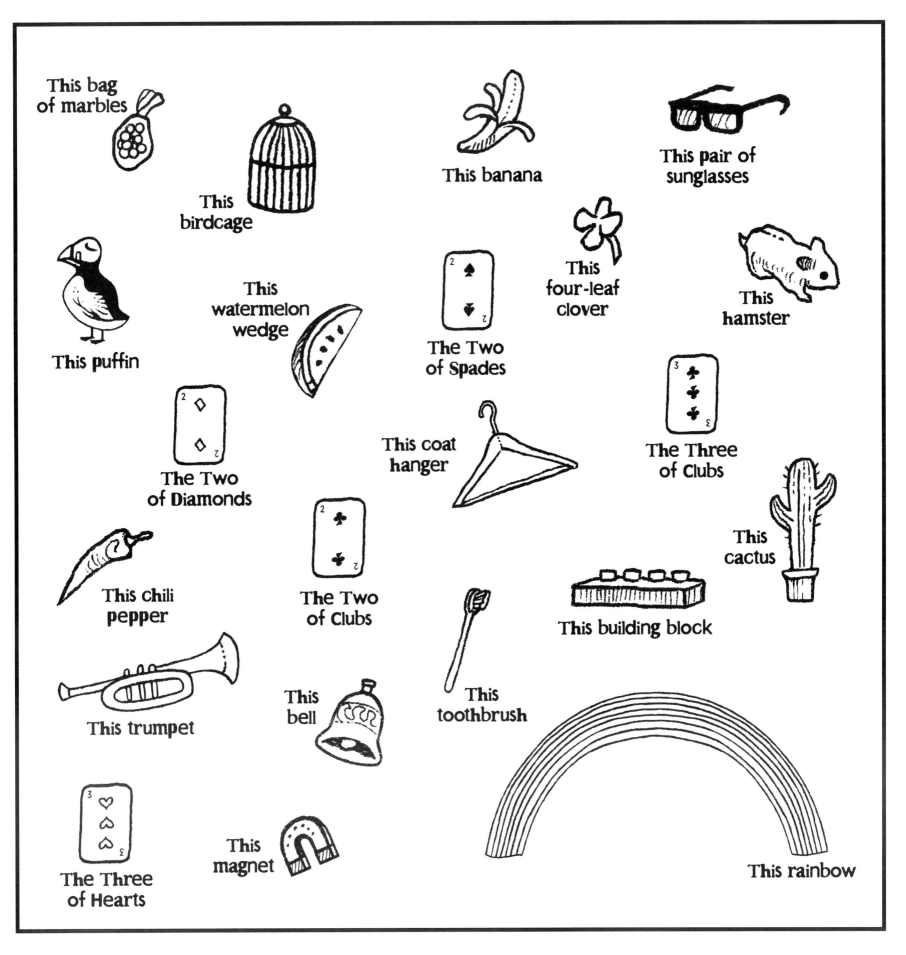

All the Answers

A birdcage and a toothbrush

A chili pepper and a four-leaf clover

A bell and the Three of Hearts

A bag of marbles and a cactus

A full moon and the Two of Hearts

The Two of Clubs and a puffin

A banana and the Three of Clubs

A rainbow and the Three of Diamonds

A corn on the cob and a *Stegosaurus*

A padlock and the Two of Diamonds

A carrot and an ice cream

A megaphone and the Two of Spades

A pair of sunglasses and
a wedge of watermelon

A bouquet of flowers and a hamster

A building block and a magnet

A coat hanger and a teddy bear

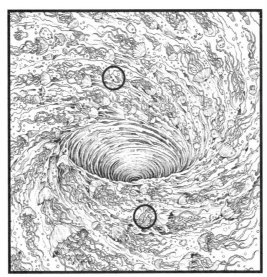

A pair of odd socks and
the Three of Spades

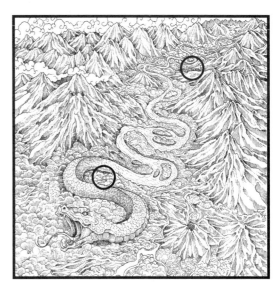

A cupcake and a trumpet

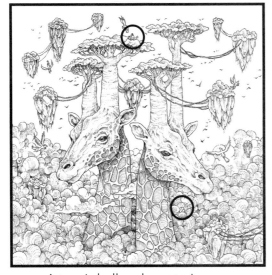

A tennis ball and a watering can

The end

Share your creations:
#geomorphia